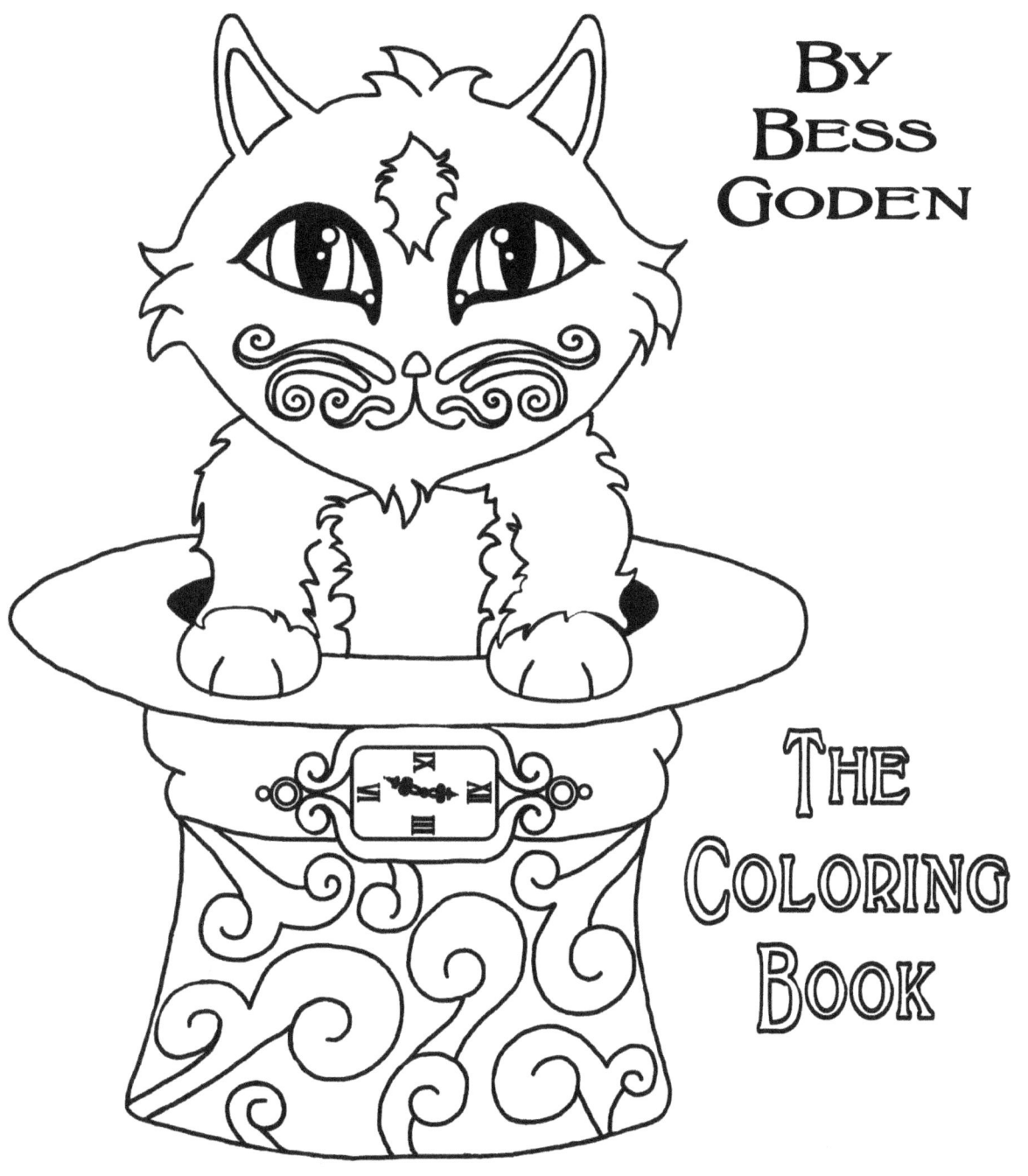

―――――――――――――――――――

*Dedicated to my loving friends.
In particular:
Robert Vitale for helping me come up with the
book's concept,
and
Christopher Imbrosciano and
Jennifer Walling-Macedo for cultivating my sanity.*

―――――――――――――――――――

Copyright © 2016 by Bess Goden
All rights reserved. This book or any portion thereof
may not be reproduced or used in any manner whatsoever
without the express written permission of the publisher.

Printed in the United States of America

First Printing, 2016

ISBN-13: 978-1539310983

ISBN-10: 1539310981

www.SteampunkParliament.com

TABLE OF CONTENTS:

1. Phineas J. Huggins

2. Jervis Wordsley Fuzzington, Esq.

3. Lord Bally Birdchaser III

4. Ms. Regina Nimblepaws

5. Ms. Catarina Verbosity

6. The Cattington Fete

7. Mr. pinker J. Tinerkclawes

8. Lord and Lady Milklush

9. Mr. Billy D. Scruggins

10. Fluffy Hattington

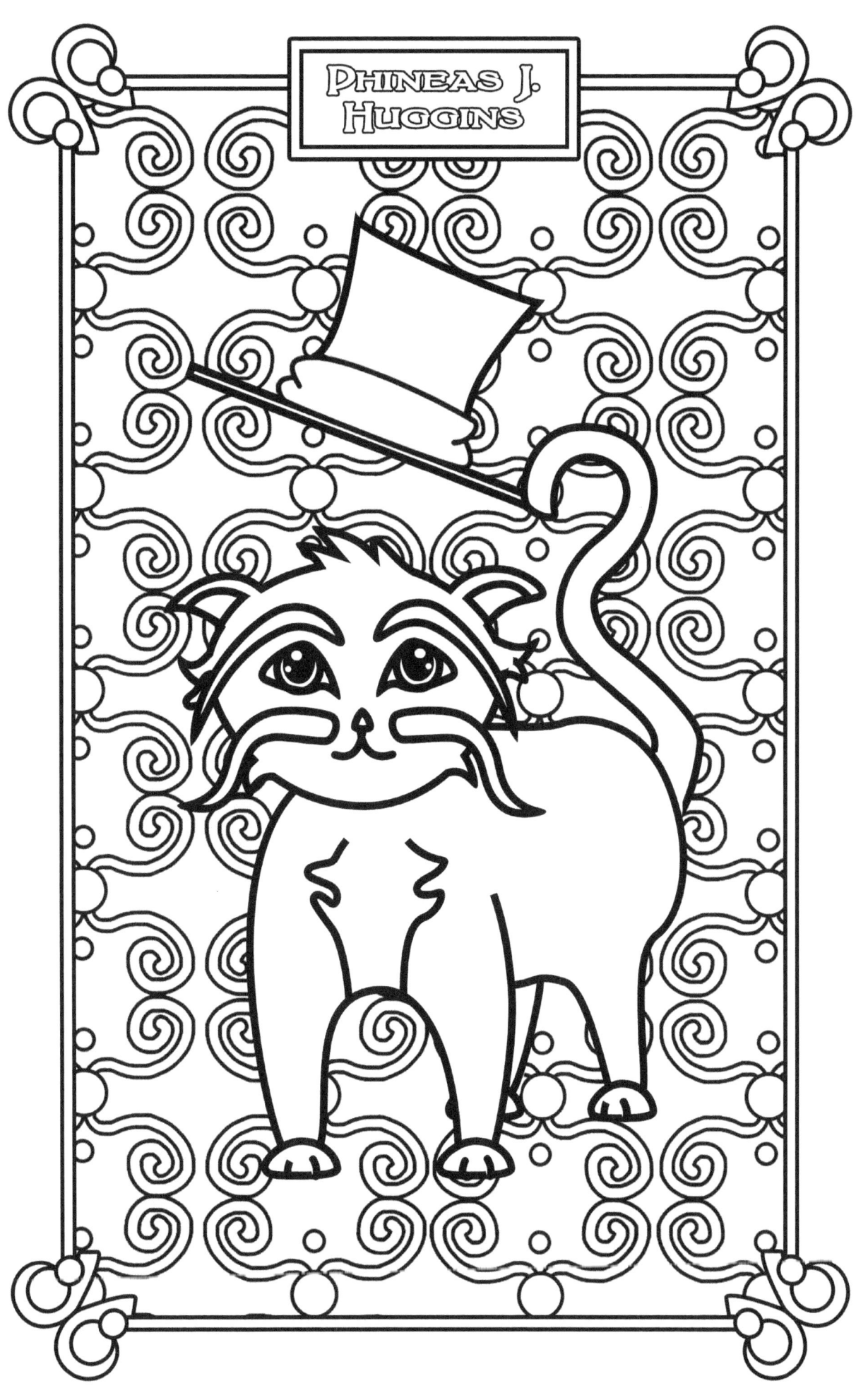

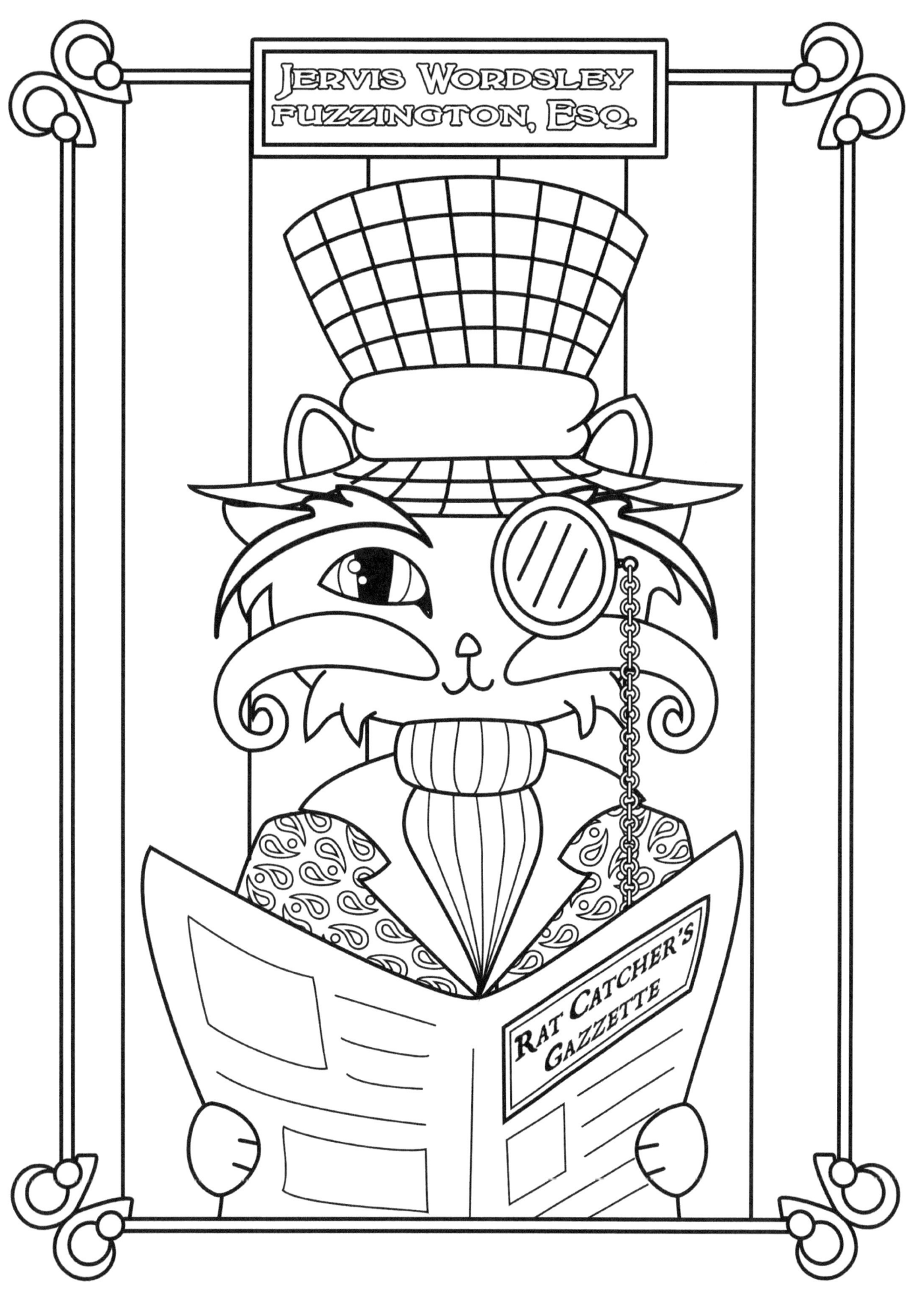

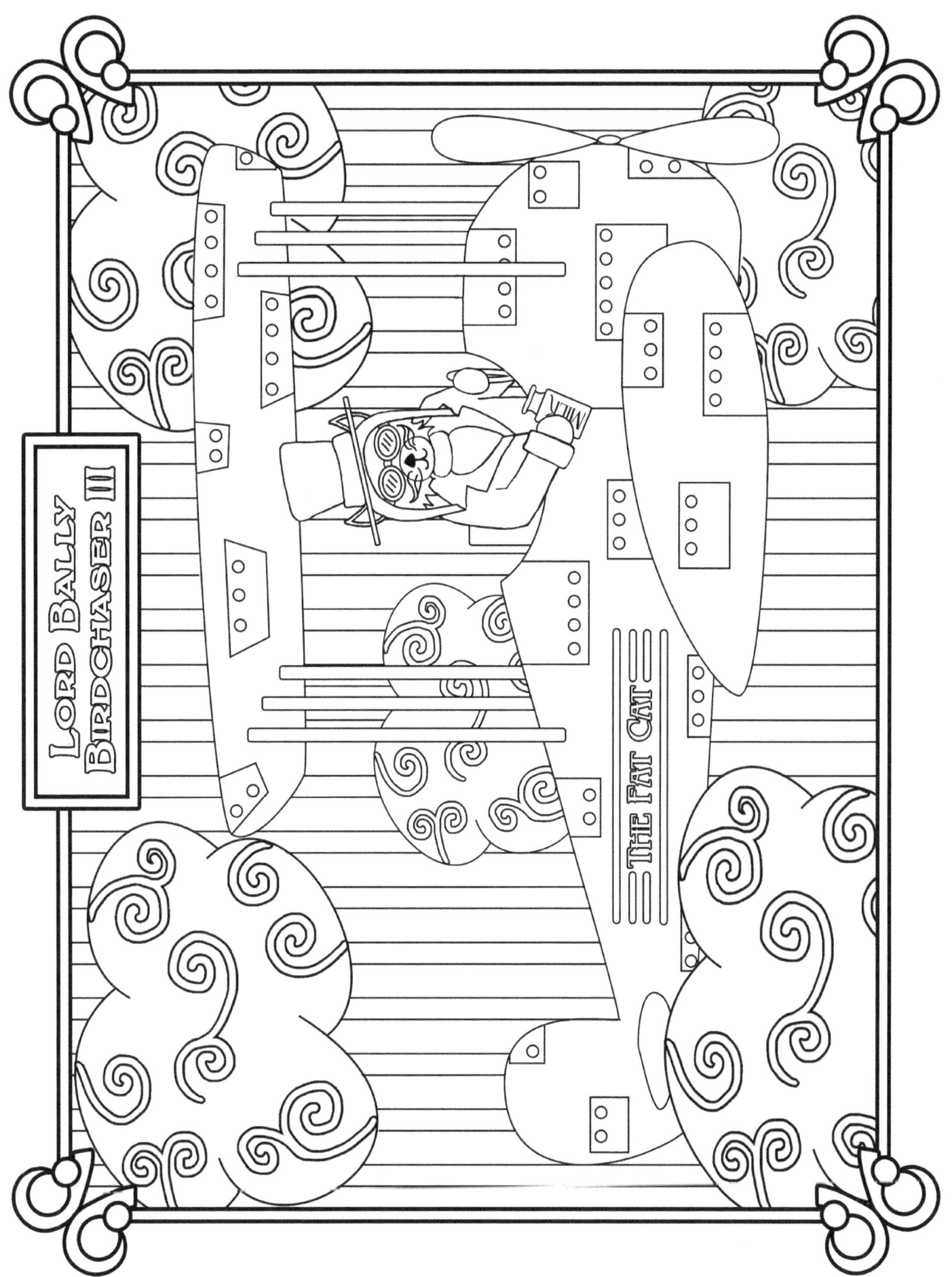

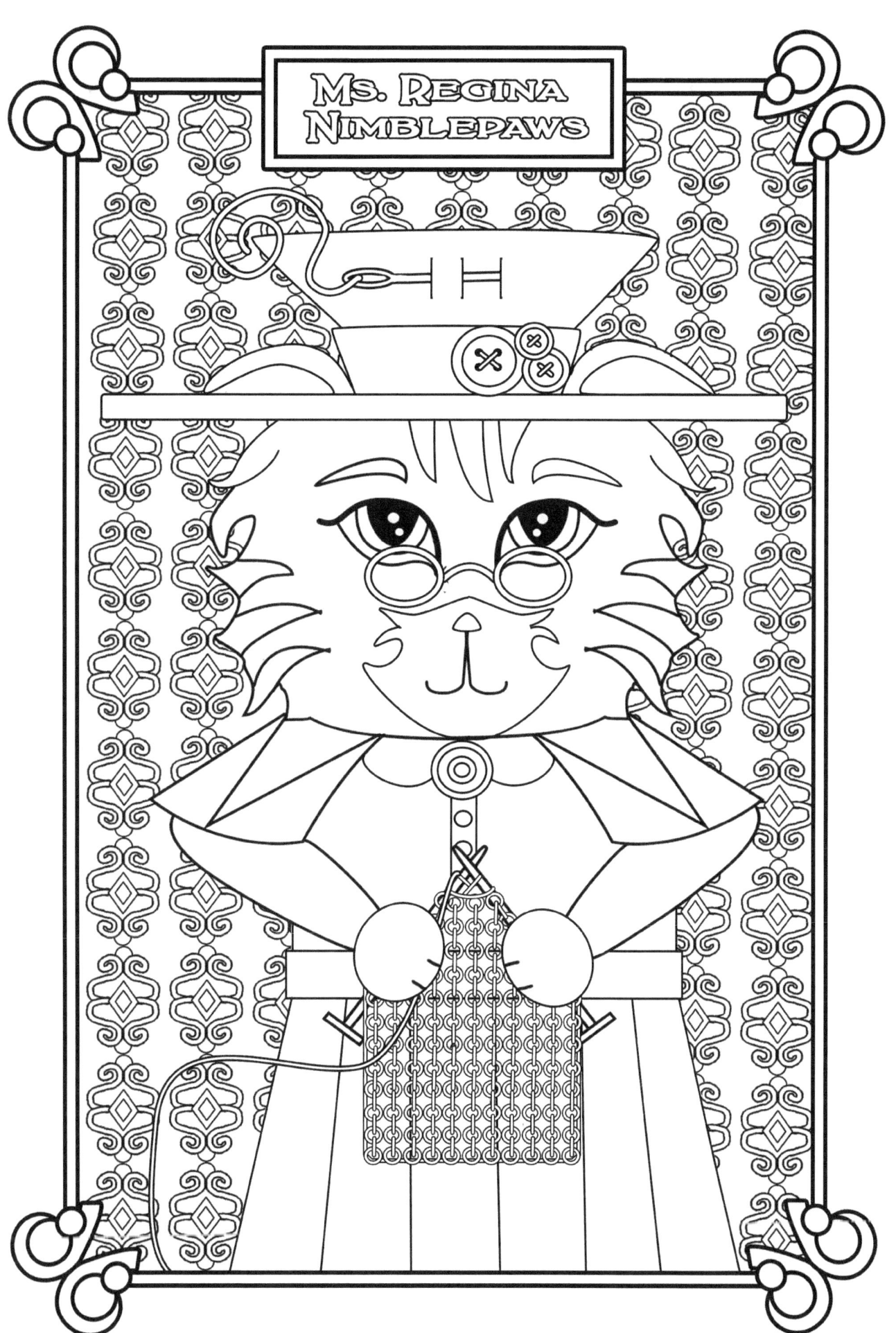

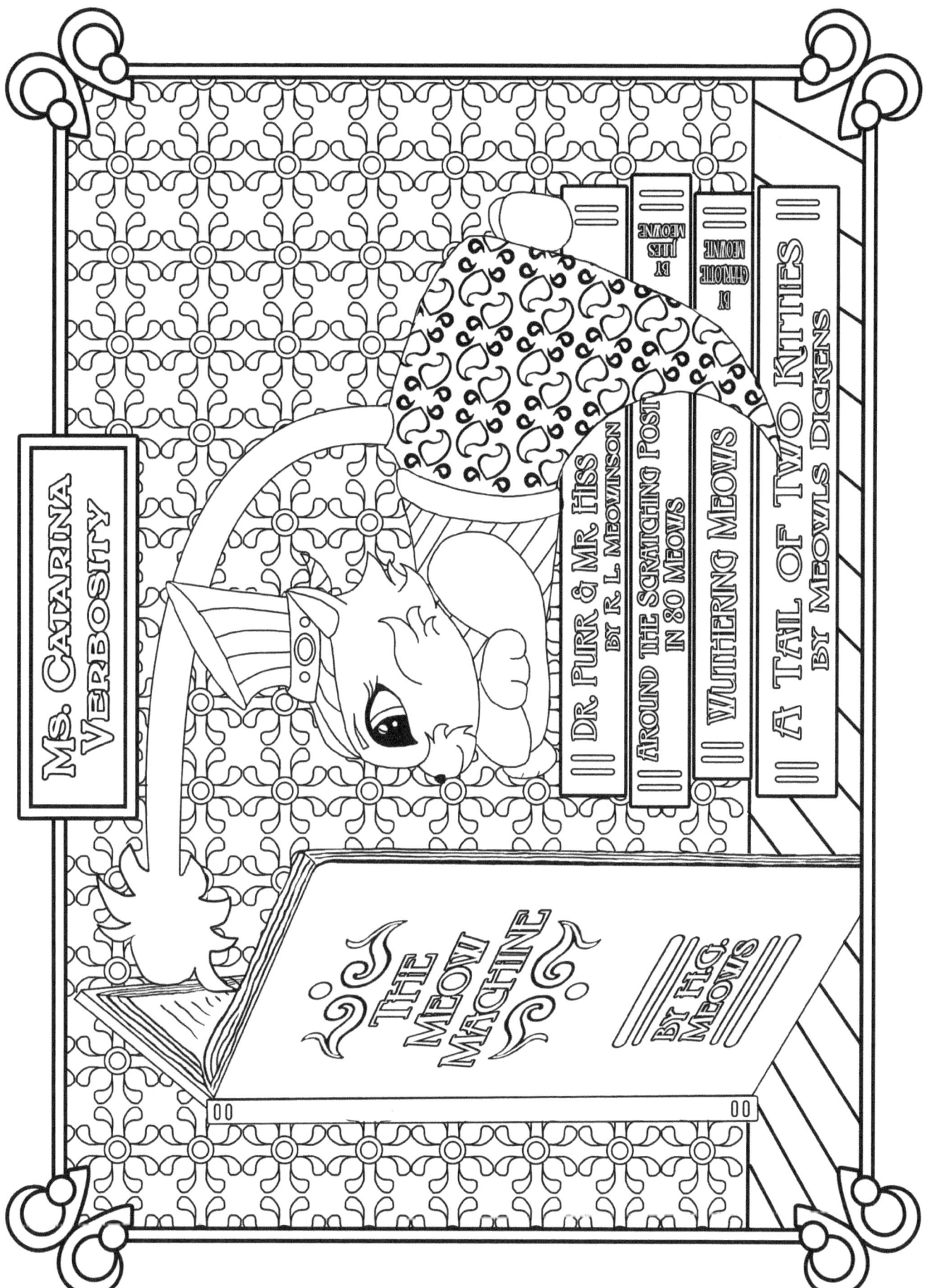

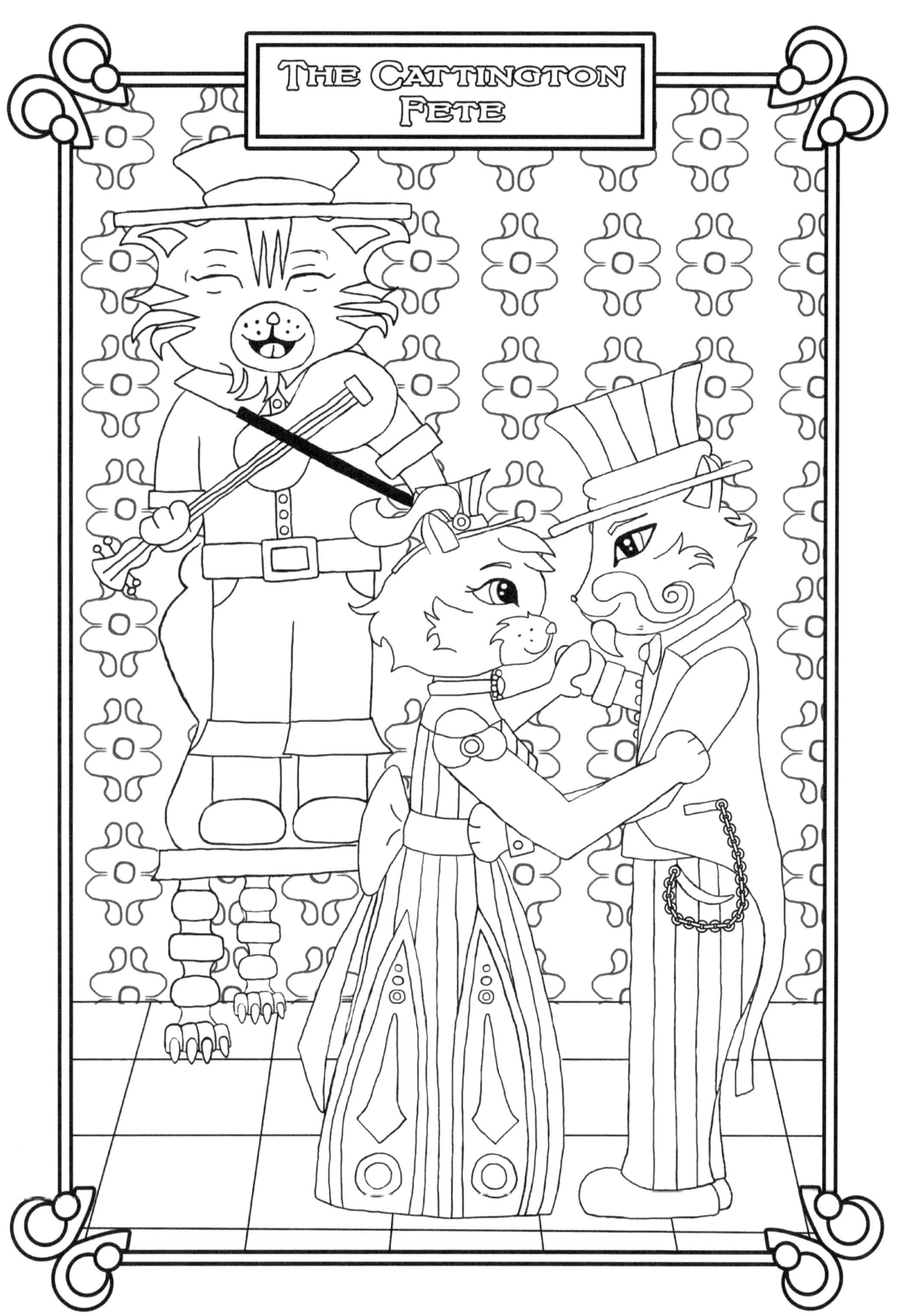

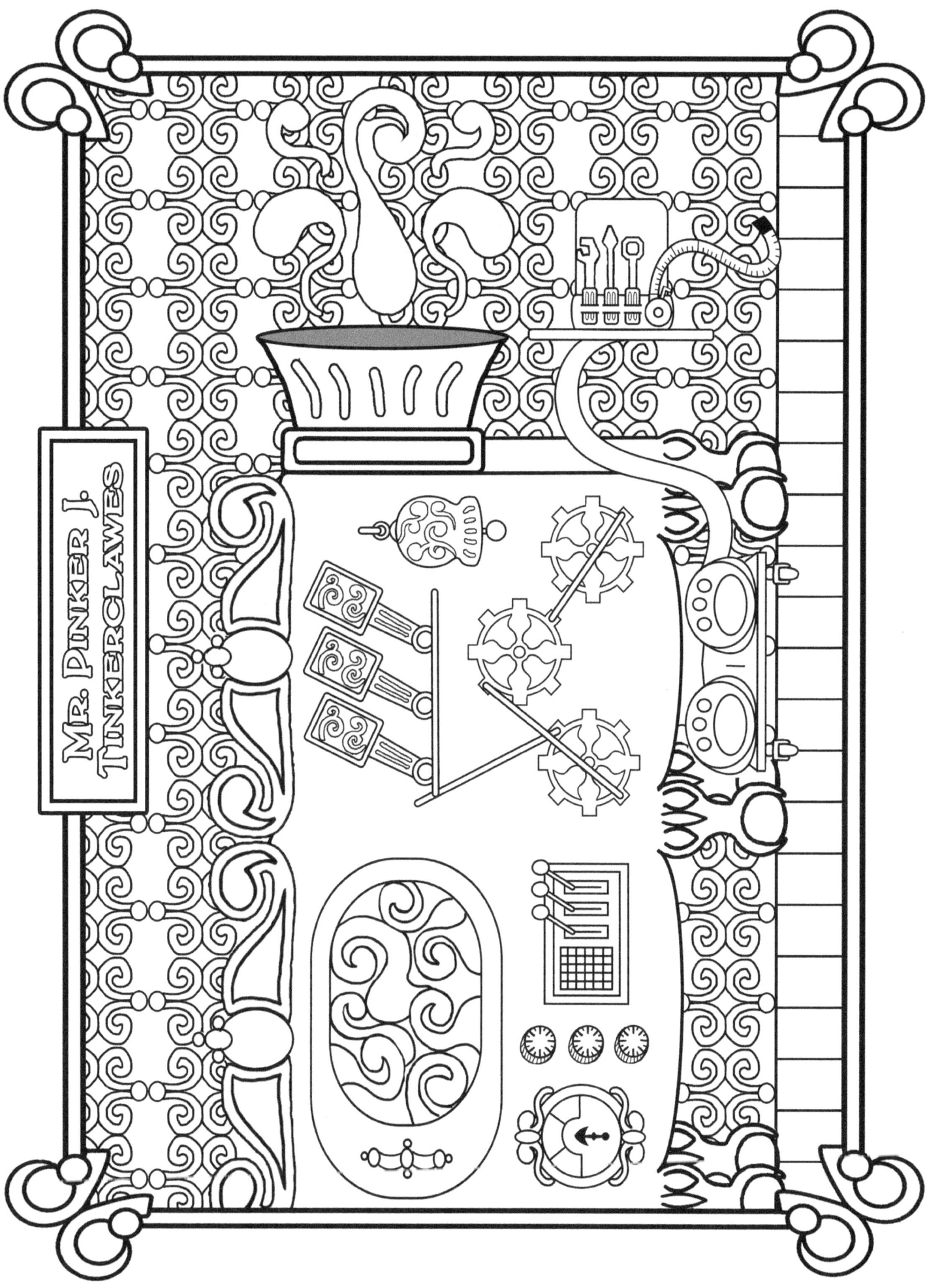

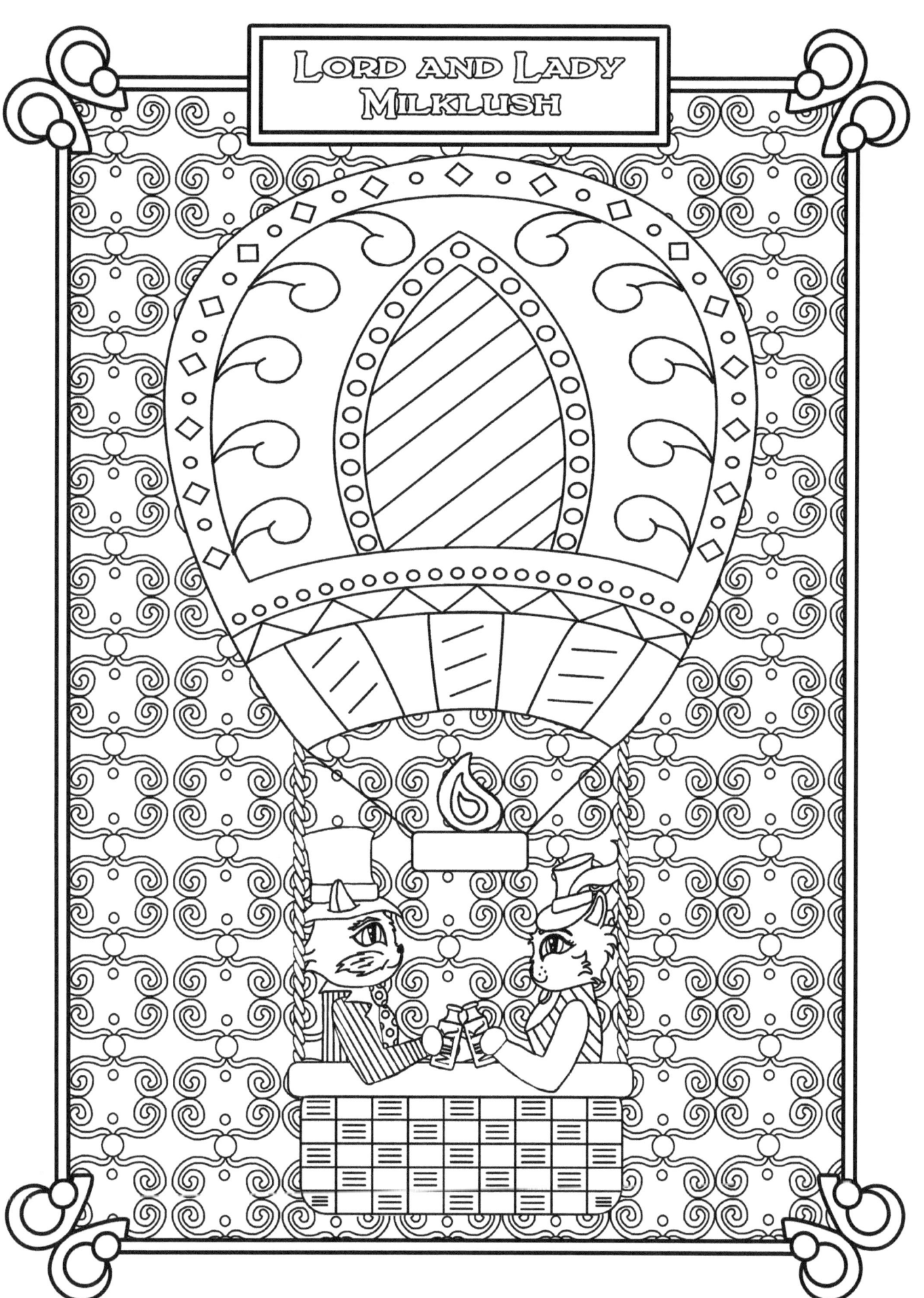

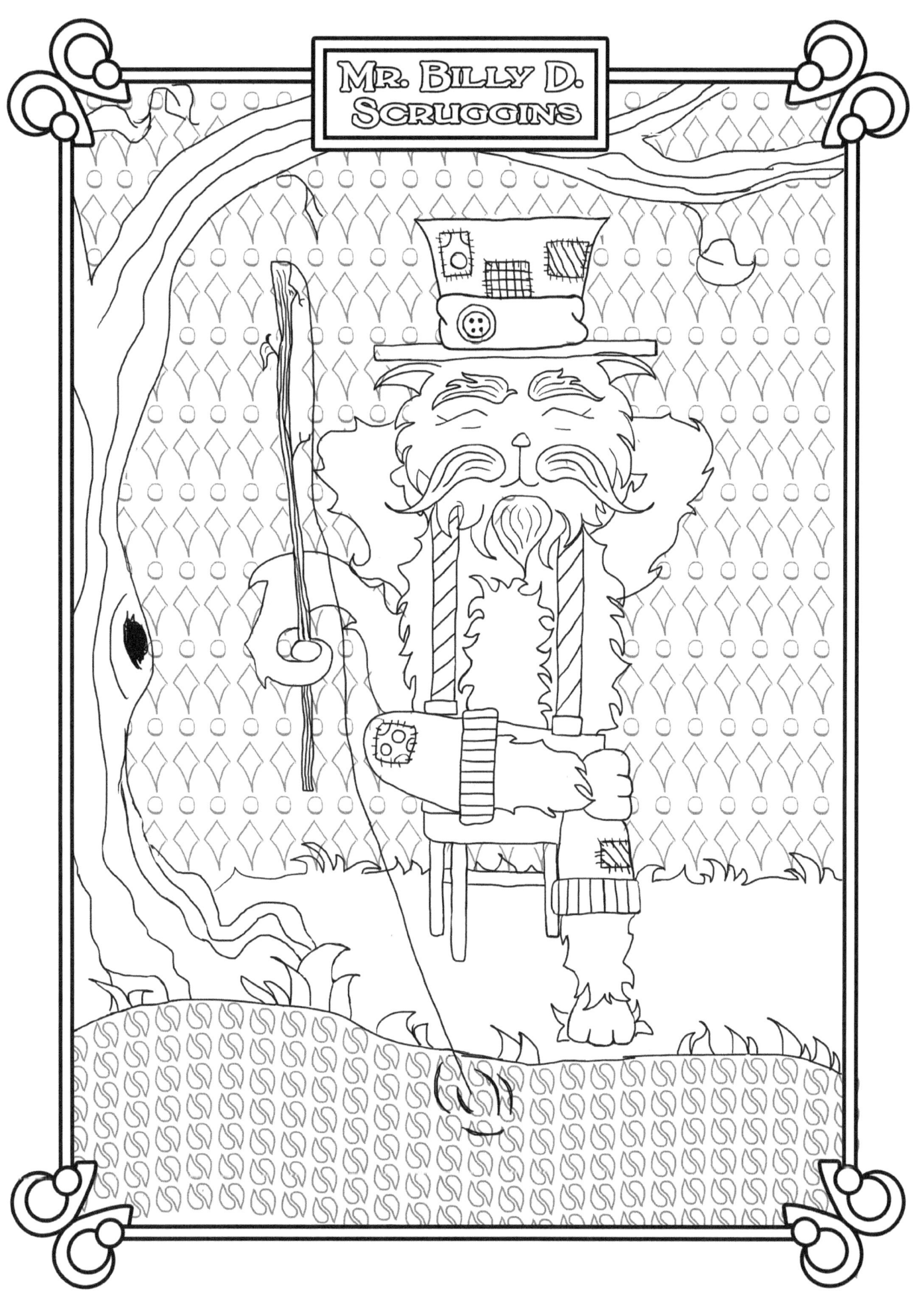

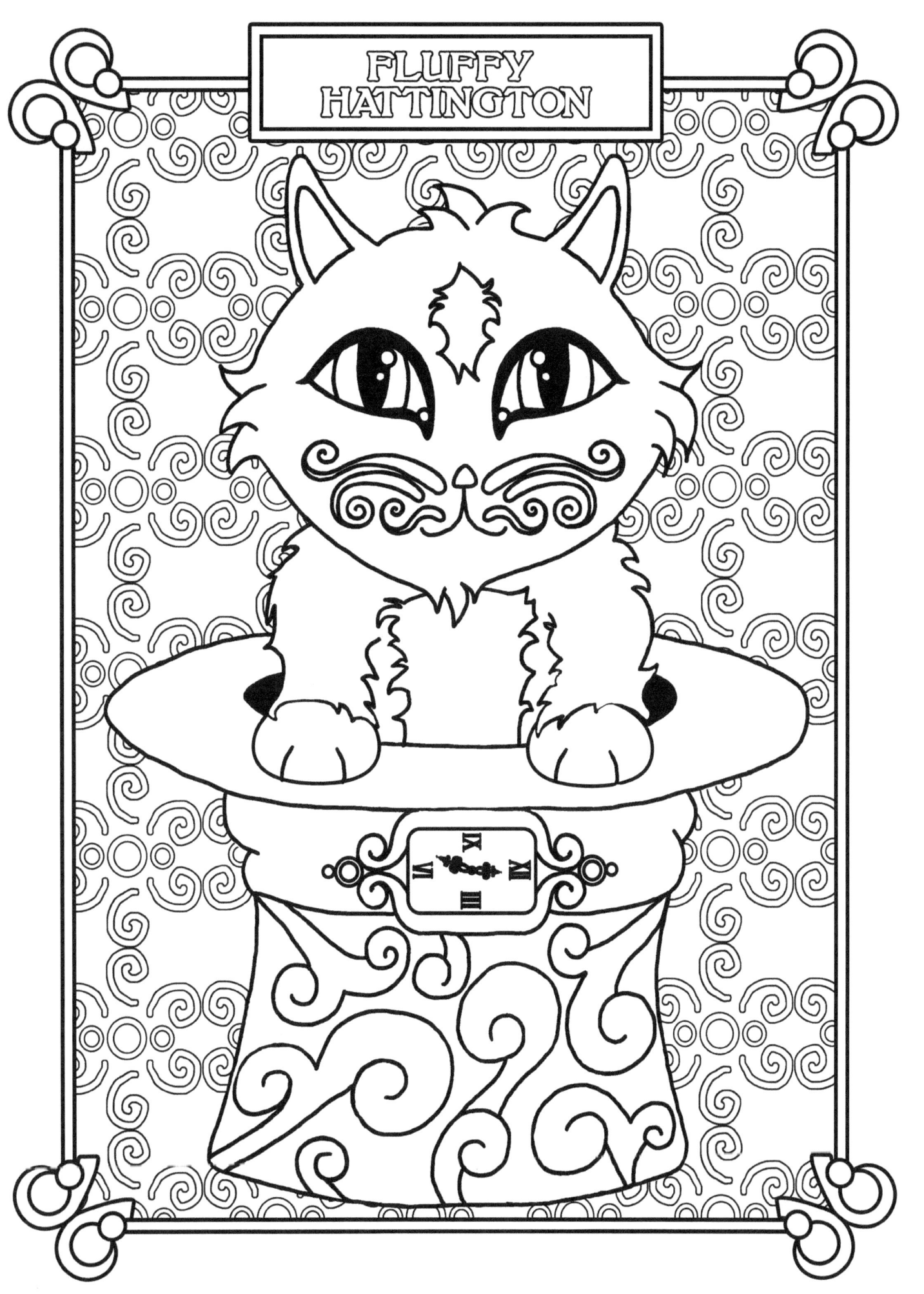

Want a Free Gift?

Leave a customer review on Amazon
and I'll send you a
Free Fluffy Hattington Sticker!

Just leave the review, (positive or negative, just be honest!),
and send your mailing address to Bess@SteampunkParliament.com.

Thank you so much for buying my first coloring book!
Your purchase really helps my struggle as a new artist
and will enable me to keep creating all the
Steampunk adorables your little fingers can color.

Love and Kisses,

Steampunk Bessie

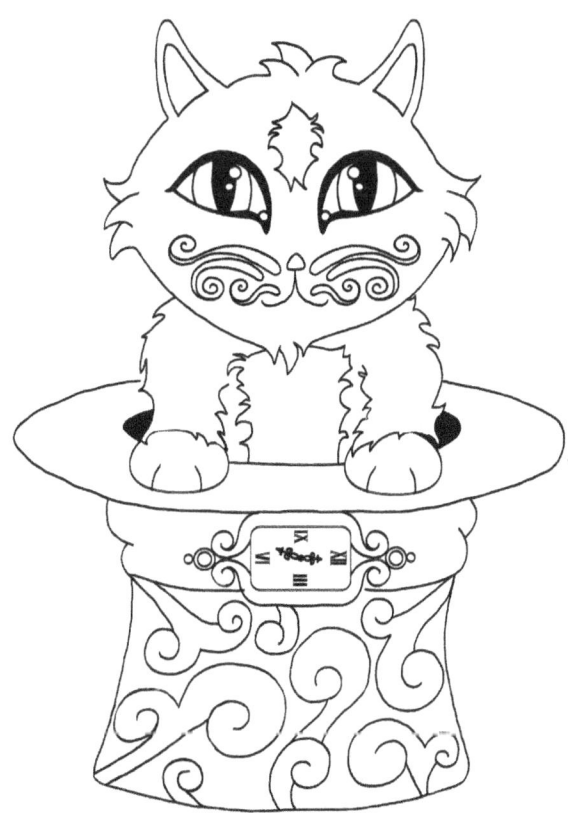

www.ingramcontent.com/pod-product-compliance
Lightning Source LLC
Chambersburg PA
CBHW080533190526
45169CB00008B/3140